NICK ZINNER

ZACHARY LIPEZ

STACY WAKEFIELD

Published by Akashic Books
Photographs © 2010 Nick Zinner
Stories © 2010 Zachary Lipez
Designed and edited by Stacy Wakefield

ISBN-13: 978-1-936070-62-6
Library of Congress Control Number: 2010922721

Printed in China
First Printing

Akashic Books
PO Box 1456
New York, NY 10009
info@akashicbooks.com
www.akashicbooks.com

England, 2009

England, 2009

Guadalajara, 2006

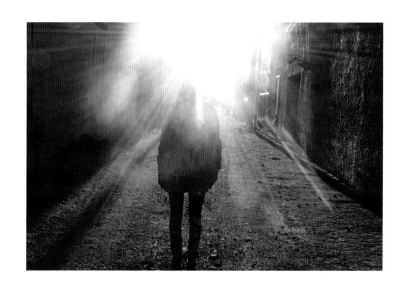

Marfa, 2008

I.

BORING
COKE
STORIES

So there was this one time Nate, Ray Ray, the Nguyen sisters, and I are about to jump out of a plane and Ray is like, "Either of you guys holding?" and we're like, "Ray. We're about to jump out of a plane." Thinking how vain and blind to the glory of life it is to jump out of a plane for reasons other than to rescue hostages or kill

enemies of the state. Thinking about how my atheism isn't the atheism of my forefathers, but the shallow and thoughtless atheism of a Bedford Avenue shopgirl— more contempt for fat Midwesterners than certainty of any scientifically mandated order. Wondering if I piss myself, will the rushing air dry me before I land? Asking myself if the wolves will clean the shit off me before my body is found in the woods. If Ray Ray or Nate are holding, yeah, fuck it, I'd be good for a bump.

So this one time I'm waiting for my guy, sitting at my apartment for like an hour and a half, watching *The Nanny*. Guy calls and says he's in his car outside. Meaning either he's sitting in his car outside, or will be in thirty minutes. I go outside. There's a PR dude sitting in some car. (Make? I don't know. Ask a rockabilly fan. It was dark blue.) I get in. He looks at me. I look at him.

He says, "What the fuck are you doing?" Is it racist that I just got in the first dude's car I see? Would it be racist to ask him to maybe cruise around the block a couple times? Help me find my guy? I smile my "sorry about white privilege" smile and get out. Hoping I didn't ruin his day too bad.

So there was this one time? I was at The Ridge or The Lodge or The Third Rail, whatever the place that used to be Kokies is called, and I decide to call my guy, Iz—whose name I'm pretty seriously into as I like the idea of scoring coke off one of the extras from *Arguing the World*—and I get his machine. I leave a detailed message consisting of, "You out? I'm at North Third and Berry." At the time, those white hoodies with patterns like Santa's cataracts were all the rage with dealers, hood rats, and gay club kids. And of course

the white twenty-something dullards who curse the day they were born none of these things. So when a big guy comes in, wearing said hoodie, I know he's from Iz. They're different ethnicities, but dealing drugs, despite what *The Shield* would imply, is a pretty diversifying occupation. At least on the ground floor. I can't speak to the executive level. He's playing pool with his pals and I walk up, give him twenty dollars, and he gives me a bag. Next day, Iz calls to apologize for not sending someone, as he no longer works Tuesdays. Oh, phantom pattern-design-hoodie dealer, thank you for selling me drugs. Thank you for not giving me a richly deserved beating.

So this one time, after the usual rigmarole at Mars Bar, I find myself in the magical hookup cab where the driver knows my name and absolutely refuses to take the woman I'm with home, despite me repeatedly giving

Curitiba, 2006

Massachusetts, 2007

him her address. I had been in love, or something akin to love, with said woman for eight years. She had always rejected me as too—laughable as this may seem now—young, and had married the drummer of one of the many gothically derived bands better liked than my own. Strangely enough, the drummer turned out to be a cad and now she's divorced and riding with me in a cupid-driven taxi. Not being one to blow against the wind, she starts kissing me (maybe I start kissing her; when the air is thick with rose petals, these things get lost) and then the driver refuses to take us to my place till we stop at a bodega and get beer. I assume that I must have gotten this driver before, in a blackout, and he finds me amusing. And isn't this what everyone wants—parents with stories, warm bread, sodomy, to be found amusing?

I don't remember when we stopped going to the

bathroom to do our drugs, and just started doing them at the bar, pouring little anthills of coke on the bridge from our thumb to the accusation finger. I do remember that it felt like an accomplishment, a way to separate ourselves from the dabblers who were just trying to have a good time. Whatever that is. Though prone to delusion, I'm not delusional as a type, I know that anyone watching us would think us grossly indulgent at least, and certainly disrespectful to the establishment. But I like to think we're just honest in our wants. And courteous to the girls who have to pee.

So there was this one time I had been shitting black powder for about a week and was having a hard time convincing myself that this was just a temporary situation that everybody goes through and just doesn't talk about, so I decided to see a doctor. He was decent, and gave me

plenty of samples from the doctor closet. I asked him if I needed to stop doing coke. He said that I should, but that it was more important that I quit smoking. I cut down on my smoking. I still owe him money.

I remember this one time, Nate, Ray Ray, Hoy!, and I drove to Atlantic City at five in the morning. We didn't have coke but figured we'd get some there. Nate had a bottle of Stoli from the bar, so we poured that into a jug of Gatorade and drank it on the way. When we got there we took pills and then I fell down a few times. The casinos threw us out, the boardwalk rickshaw drivers were getting visibly annoyed with us, and no hotel would let us stay, until Nate and Hoy! found one, just outside of my peripheral vision, that would. Nate told the clerk we were "party reporters" on assignment. Then we went swimming in the pool. Ray Ray and

Hoy! got naked but I kept my boxers on because I'm shy and it was noon. Later that night, we asked every stripper we saw (even the bullshit ones who just dance around in bikinis) but never found any coke. I do love the ocean, so no worries. When we left, the hotel clerk, in a droll Middle Eastern accent that I can only assume he was putting on for our benefit, said, "You guys are sober, what's the matter? Off duty?"

I went home once with this girl who, being close friends with my recent ex, was entirely off-limits. But she was often wearing nothing but tiny sheriff outfits and pasties, and setting limitations with a girl like that is counterintuitive. This night she was wearing a bright orange jumpsuit. She said, "I don't want to do the wrong thing here, but in thirty seconds I'm going to be naked." I could not, despite imagery that has caused

no such problem in its recollection, function. I don't know if I have any conscience per se, but, again and again, cocaine, in practice if not in theory, has provided a moral compass.

Whenever I see some movie where drug users/dealers are portrayed as this self-absorbed subspecies of rapist— like a rapist, but bad—I think of Katharine Graham's funeral. I wasn't there, of course, as I was locked in some bathroom snorting powder off a scab, or I was twelve. But I've read about it. And the amount of blood on the hands of all the well-wishers there, the number of hands that shook Kissinger's hand like it was some sort of prize they deserved for their varied good works, was enough to induce nausea in the not easily sickened. I like to think there's more than wealth, power, celebrity, intelligence, ambition, moral certitude, and, of course,

actual physical distance separating me from the Great Men attached to those hands. Teachers and guidance counselors will try to tell you that, drug free, you too can be a Great Man. That's not true. We are born with the limitations God gave us. Our fates are predetermined and we were probably not born a Kennedy or Graham. Luckily, with our small station in life comes the freedom from having to shake the hands of mass murderers and not just pretend to like it but actually like it.

Every time a white girl gets shot in New York we all have to shift our behavior. We have to start carding again, going outside to smoke, cutting people off before they pass out . . . It's a hassle. Not to say we don't feel bad for the families, but we have enough trouble what with the terrorists and the NYU students tipping in change. And I'm sorry that I feel worse about some Dominican

kid drowning in the East River, but what can I tell you? I come from a very liberal home. We gradate our grief.

Now that Richard Price has written the L.E.S. cocaine morality tale of the foreseeable future, it's left to us literary bottom feeders to find our drug-related niche as best we can. I call dibs on the indefensible. I call dibs on the buyer without remorse, the jaw grinder and twitchy talker, or, worse, the cocaine vulture. These are my people. I enjoy the company of jerks, and I enjoy the company of jerks who are holding. If you don't think you're going to like the party, decline the invitation.

Okay. One more. I'm keeping some for myself so I don't feel like the sort of person who engages in memoir. So this one time? I was with one of these girls I keep company with, someone who, given the right circumstances, I

could really learn to like. We were at one of the Blarney Coves at eight a.m. She was in torn fishnets and I was in a state of happy confusion, like eternity had split in two and was handing out cake—the same feeling I always have when the night absolutely refuses to end and possibility is punching me in the face. The bartender was pouring us shot after shot, presumably because he was delighted that there was a woman in the bar to offset the 900 years of bitter experience sitting down the rest of its length. I had no bad intentions because I had no intentions at all, and plus, I was fond of her boyfriend. I just wanted to take things as far as they would go, and then one of us would do the right thing. Later at the Chelsea Piers, alternating between kissing and shouting at each other, the afternoon sun doing the same with the water before us, no one seemed to mind at all that we were occupying a bench spilling tequila

Porto, 2006

all over each other, and why would they? The city does what it's supposed to sometimes. And, eventually, the right thing was done. My glasses broke. She said that I shouldn't come over, as that would be pushing it. It was four in the afternoon and we were on 34th Street, so I had to agree. She told me that there was Krazy Glue in my pocket, because around noon I had decided that my glasses were going to break and that I should buy glue. I was amazed at my own sense of responsibility. What a grown-up! I didn't kiss her again. I got a cab. I went home, my glasses at an impossible angle and my face and hands hard with adhesive. My roommate laughed till she saw spots when I spilled into the apartment. She gently shoved me to my bedroom, turned down my light, and, going back to her yoga, Talking Heads, and sun-dappled curtains, shut the door.

England, 2009

France, 2009
Mexico, 2008

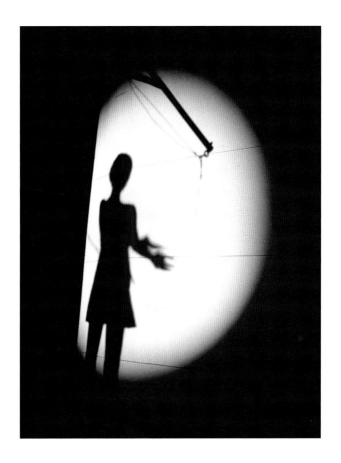

New York, 2006

Harar, 2010

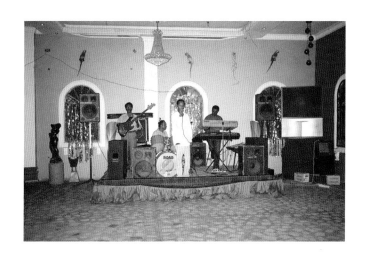

Harar, 2010

Los Angeles, 2007

Los Angeles, 2006

II.

STREP
THROAT
LOVER

There are white clouds at the back of my throat. And the throat is the center, not that sweating day-laborer in my chest. The romantic can have the heart. But the throat, the tonsils, the tongue—they're for the strivers.

Streptococcal pharyngitis killed George Washington. The Internet told me. The doctors said it was inflammatory quinsy. Cute. He got it from a wrathful god. Who got it from the Demiurge, who got it from the Monad, and so on, down to the turtle. Contagion is our birthright and I put it to my lips because I'm not afraid of anything that I can put in my mouth.

When you get strep throat at least three times a year, the Latino girls at the pharmacy counter look at you queerly. Eventually they told me to stop going to the doctor for prescriptions, and they'd just slide me the knock-off penicillin. Why pay a doctor to tell me to stop sharing keys and putting my tongue in unsanitary places? I was very pleased and started entertaining strange thoughts about the pharmacy girls full of something other than gratitude.

Chicago, 2005

Berlin, 2009

Like arms control and greeting cards and foreign language no longer being required in middle school, pasteurization has made us weak. Our bodies susceptible to the most dilettante of microbe. Soap has turned on us, as our old selves suspected it would. We knew our parents were lying to us, or at least foolish to take the word of a babysitter in a lab coat.

Some people who can't stand to be mediocre become great. Either through art or killing they become the opposite of what they saw in themselves and despised. Some people who can't stand to be mediocre are overwhelmed by their own mundanity and are bitter until they're dead, by their own hands or the life they inflicted on themselves. Some people, hi, who can't stand to be mediocre just don't try. They learn to stand it. And some other people find those people,

and their studied lethargy, attractive. All bodies, all carriers, all welcome.

When you first get strep throat, it doesn't start as a tickle. There's no nuance or tease. You wake up, already regretting so much, and you can't swallow, and your forehead is hot. Your bones lie there in the bed helping you put off finding a flashlight, looking into the bathroom mirror, seeing the smoke at the back of your throat. Infected again, because the tongue is the root, and the root is corrupt. It is time to go to the pharmacy. And try to smile, and try not to make any jokes about it because that is so creepy.

I know that a lot of people take showers after sex. Germaphobes, chronic cheaters, people who value a nice shower over their partner's feelings. But other

Chicago, 2005

Köln, 2006

than certain acts that require it, I never do. I'm a real snuggle bunny. Or I want to turn the lights up, have them go through their purse to see if they have more drugs, and then talk about my CD collection for another seven hours. And as anyone will tell you, in the a.m., it's a long cruel slog from the bedroom to the tub. Let hygiene be its own hunter and provider, when romance meets sloth. It's not that I don't care if I get sick, but no amount of industry on my part can forestall the inevitable, so why make a scene?

After getting diagnosed, or having a cozy enough relationship with your pharmacists that a diagnosis is unnecessary, you purchase your penicillin or amoxicillin, seven to nine days' worth, depending. Depending on what, I have no idea; I've always been given varying amounts. I privately hope for the seven-

day, as you're not supposed to drink on antibiotics. I don't know anyone who doesn't, though it's a useful excuse if you're tired of your friends. On the seven-day regimen, you can start drinking on day four in good conscience. On the nine-day, it's pretty bad form to begin before day five. Either way, you're not contagious after day two. So do whatever the hell you want.

Once or twice, I've gotten strep within a month of the last batch. This, I admit, is frustrating. I even considered, briefly, going to another pharmacy. But in the end, I love my girls just too much. And the thing that I like about people is that they're tolerant.

Barring some tribe yet to be discovered and eradicated that holds the ill and infirm in some sort of religious esteem, I imagine it's a pretty universal survival trait

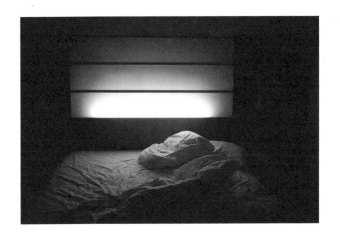

London, 2010

to fear and hate the carrier of disease. And it's one I support. I subscribe to all the universal survival traits. That being said, if you're sick, I won't turn you away. There are a lot of traits, common to humanity, that cause me more distress. Racism, homophobia, nationalism, whatever it is that makes people say, "Warmer, warmer, Miami," when they're forcing you to guess their age at a bar, are all things I could do without. I'd much rather spend time with someone with maybe a little cough. A barely detectable fever. A little personality can make up for a lot. There's room on the couch and I have plenty of soup, but only one spoon.

Hamburg, 2009

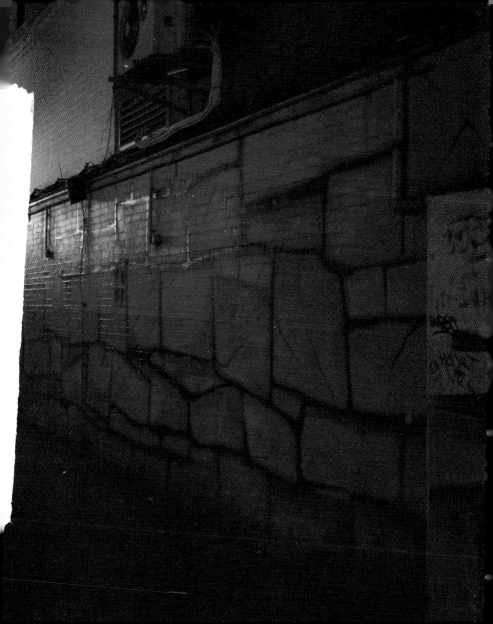

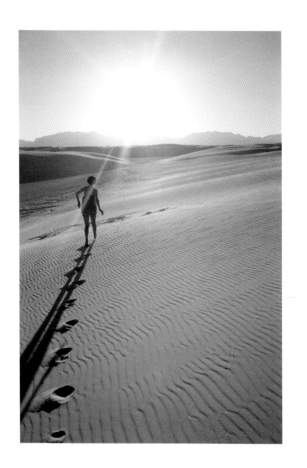

New Mexico, 2008

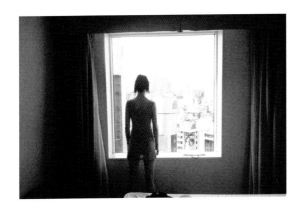

Tokyo, 2006
Long Beach, 2009

Tornillo, 2008
Tornillo, 2009

Panama, 2008
Los Angeles, 2009

Montreal, 2005

Hamburg, 2009

III.

MY LETTER OF
RESIGNATION

Dear Fred, Dearest Nancy,

If, as the kids say, modern life is war—and I believe it is—then I no longer wish to be employed at The Strand Book Store. To put it another way, more responsive to Fred's upbringing than Nancy's Go Go '70s background: Maggie's Farm—I no longer wish to work on it. In fact, I wish to so terminate my relationship with Maggie's Farm that I no longer understand the reference.

The reasons for my self-termination are plentyfold. Firstly, I do not enjoy going to work. On time or at all. But especially on time. My tardiness should never have been an issue, and certainly not one that was brought to my attention. Working at a bookstore shouldn't be a popularity contest. This isn't one of those offices where cupcakes are currency, and awkwardness—true

and painful awkwardness—is mined for humor by the British. This is a bookstore. Or, at least, that's what it says on the sign outside. Now, after three and a half years spent shelving the likes of *Reckless Sunbeams: Finding a Life Through Love*, I have my doubts.

And let me just tell you, when management told me to stop drinking on the job, a part of my childhood was stripped away. My father worked in construction or finance or was a tenured professor and all I've ever wanted was a job I could be drunk at. And, for the record, I NEVER drank on the job. I was, in fact, always still drunk from the night before. There's a big difference between Old Grand-Dad between the stacks and having spent the morning reenacting the McCarthy-era education reel *Star-Nosed Mole Vs. The San Andreas Fault* with an NYU mod whom one

picked up at Morrissey Night. You would think that upper management, with their highly developed sense of smell and ingrained inclinations, would know where on the alcohol timetable a person was. My drinking on the job would be like cavemen fighting the dinosaurs—fun but unnecessary.

I don't want to waste your time with the usual complaints about the quality of the books that I shelved, day after day, in the unchanging weather of the basement. My mother birthed me with a certain expectation of disappointment, but she'd have to lower the bar considerably before I add literary criticism to the pyramid of disenchantment that I've managed to build for her. If anything, my work at The Strand has made me more sympathetic to authors. Or at least more suspicious of those who think funning on them is the

London, 2009

Los Angeles, 2009

same as speaking truth to power. The literary world is innocent. Jews without any real ability need to do something, and there will always be someone writing short stories with titles that are longer than necessary. The author of "Marc Almond Wears a Wristwatch (Because He Wants to Know What Time It Is)" is neither Prime Minister Botha nor the Coca-Cola corporation, and I won't act like he/she is. Having said that, I'll be glad to go back to reading magazines exclusively on the subway. I don't like the way that people take a book in hand as some sort of signifying badge of membership in an elite. You don't see people with bikes exchanging smug looks with other people with bikes. Well, okay, you do. But I don't like that either.

When I was 25 I swore that I would never be the cool guy in his thirties at the bookstore, playing in

a semipopular band, sleeping with 21-year-olds. That would make me a failure. My success is that I am in a truly unpopular band and I sleep almost exclusively with girls in the 23–26 range. I am all too aware, as I had it pointed out to me by Samantha at the registers, that men who are self-deprecating while slyly bragging about fucking younger women are truly despicable. We fit somewhere on the social hierarchy above pedophiles and below male models. With the film actors who talk about how doing blockbusters allows them to do smaller fare, like saying that slitting open the bellies of baby ducks for cash allows them to buy platinum collars and bells for the neighborhood strays. Thank you for that, Samantha. Thank you.

I think it's important to not be delusional about the sort of man or woman you've grown up to be, but you

also have to avoid being a bore or—worse—clever. If you have to be that anarchist who hangs himself in the backyard of the bar, first set down a tarp or some sort of throw rug. There's always a cleaning crew, and, if you have one essential goal in life, it should be to make their lives no more difficult than absolutely necessary. I suspect that my behavior at work is making other people's lives exactly that, and I am not without a conscience.

There are those who will tell you that the doing of the work is almost as important as the quality of the work. That effort and striving, just trying, defines one's character. I don't take issue with these people's standards. And, while I prefer to stay in bed until well after three in the afternoon, I'm not opposed to hard work, especially theoretical hard work, of an academic

nature, performed by other people. I'm just saying that a lot of the author/prisoners that these people advocate for go on to kill again upon their release. But do I digress? I do. I'm sorry, Fred. I'm sorry, Nancy.

But who will apologize to me for the digressions that have been foisted upon me and my plans? When is my Off-Topic Day Parade, with politicians glad-handing babies and homosexuals protesting on the sidelines? I know that I'm not the only one who once had perfectly fantastic reasons for moving to the city. The majority of my coworkers, if the break room chit-chat is any indication, moved here for the mediocre Thai food and the plentiful artistic forums to express their first-world hassles as some sort of Gaza-level tragedy. For myself, I moved here for the poetry, the hard drugs, and the roving gangs of loose and insecure publicists. If, while

describing the dry, defensive, overeducated Berkshires-by-way-of-Athens, Ohio detritus of my existence, I have seemed flip or even—ha—resigned, it's because working in a bookstore for so long has numbed me to dramatic possibility. This, I think you'll agree, must change.

Goodbye, dear sweet bosses. You've been really okay. Tell the gang that I love them and the union that I think it's cute the way it fumbles at the lock to the door to dignity. Tell Matt on the third floor that I hate every shirt, ironic and non, that he's ever worn. And, most importantly, please tell Samantha (who I suspect is really named Becky) at the registers that I burn for her. Tell her that I burn to be the sexual stopgap between her MFA and her assistant editorship at *n+1*, that I yearn to be the bad actor sweating over her shuddering whiteness, and if she ever changes her mind about that

oft offered, never accepted drink after work that I am, now and forever, "after work."

Would you do that for me, Fred? Nancy? Thank you. You're mensches.

I Will See You Around,
Zachary H. Lipez

Tokyo, 2006

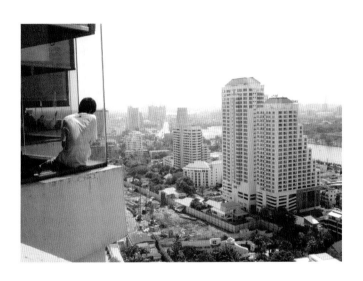

Bangkok, 2006

Ethiopia, 2010

Dire Dawa, 2010

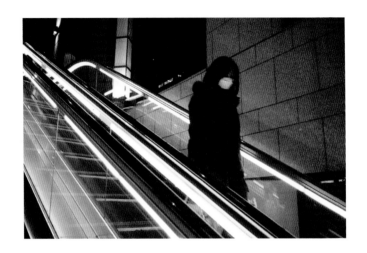

Tokyo, 2010

Perth, 2010

IV.

I LIKE MY METAL LIKE I LIKE MY WOMEN . . . FALSE

I was the sort of teenager who read James Baldwin. Rather, I looked at the words of each page before turning them, until I got to the last page. Then I would tell people that I just read James Baldwin. I was quite

moved by the fact that I was reading him. I might be being overgenerous with myself by saying that there's a "sort" who does that, but that's who I was.

I hated heavy metal as a teenager for the best reasons. The metal kids sat in the back of the bus and didn't invite me to have sex with their girlfriends. They also never let me play Mudhoney on the bus stereo because Mark Arm "can't sing." Back then, I at least had the courage of my convictions—if you asked me if I liked metal, I'd say no. Heavy metal is sexist. I like Social Distortion. But the metal kids didn't ask. They just took my tape out and handed it back to me, before popping in GN'R *Lies* and returning to the emergency exit.

The girlfriends of the metal heads, a notoriously tactile group whose names all ended in "y" or "i," were good

San Francisco, 2009

Warsaw, 2006

to and for me. They all started smoking cigarettes at twelve and had bad reputations that had more to do with their mom's marital status/job at the mall than their being any more promiscuous than your average fifteen-year-old.

Our community was divided into two towns—Lanesboro, where we were simple and poor, but stalwart and true, and wore our honestly hunted dire wolf pelts for warmth—and Williamstown, where the entire population was named Whitney, owned mistreated unicorns, and played soccer. For fun. Girls from Lanesboro wore close-fitting denim and they had a way of sitting just close enough to make you think that maybe, hope against hope, they might inflict some of that bad reputation on you. Sometimes, when even your *Emmanuelle in Space*–fuelled fantasy life includes

a disclaimer that nobody will ever really want to touch you, a tease can be a real kindness. And to Nicki— feather-haired second-in-command of the bad girls (right between Lori and Anchi), whose feelings were so hurt by my article in the school paper that compared Mötley Crüe negatively to Jane's Addiction—I now see how stupid I was. I wasn't wrong, exactly, but, in a handy bit of foreshadowing of a lifetime of throwing everything fine and tight-jeaned under the bus of my clever, clever opinions, I sure as hell wasn't right either.

It is a popular thought that everyone, on the inside, suffers equally. We've been told that, in high school, all are tortured by the same insecurities and familial discord. The head cheerleader cries herself to sleep, wracked with despair over her silver-dollar nipples. The lumbering meat socks on the varsity team wonder

why their dads hate them. The entire incoming freshman class of Harvard thinks themselves inferior to the incoming freshman class of Brown. Their stories should be told. And this assortment of jerks should tell it, I'll even lend them my pen. As soon as I pry it from my eye socket. But no one suffered equally. I suffered worse than the animals above me, and those below me suffered far worse, sometimes by my actions. In the rare instance that I found an insect smaller and more socially inept than myself, I was not averse to tugging at its wings.

Nowadays, thanks in part to the bus-ride Rickis, Nickis, and Cindys of my youth, I like metal just fine. Not enough to go to shows, but enough to wear the shirts and occasionally do the dishes to Dio-era Sabbath. It's a useful psychic remedy now that the city I love has

become an expanded college town full of graduate school rowdies and their fear of shaving cream and low-income housing, who listen to the misbegotten spawn of that Canadian bore Neil Young, exclusively, while shooting HPV, like garlands, onto their counterparts' luscious blond hair. I sit on my bed, listen to Watain, and draw elaborate graphs of my high school humiliations. And in them, all the soccer players look like my new neighbors.

I did not grow up during wartime. I have never, in any real sense, suffered. I know I said I suffered earlier, but I was using dramatic license, or kidding, or lying. I grew up in a state of privileged irritation. I suckled on a tit of brie and always had an unkind word for the school janitor. Truly, I was a shit. Now I read the great books and barely comprehend them. The sad ones make me sad and I hate that there's no one around to swoon over my sincerity.

Austria, 2009

Curitiba, 2006

All the same, I have gotten over nothing, forgiven nothing, and still roil away my nights going over slights twenty years old. Call me, all of you. I'm single, fit like a syphilitic sailor, I enjoy dancing, and I love to laugh. I have an unflappable faith that we can, together, cut open this overworked 100th rough draft of a heart, where bitter style has made everything overwrought and, let's admit it, a bit dull, and find the initial, truer heart, hidden beneath.

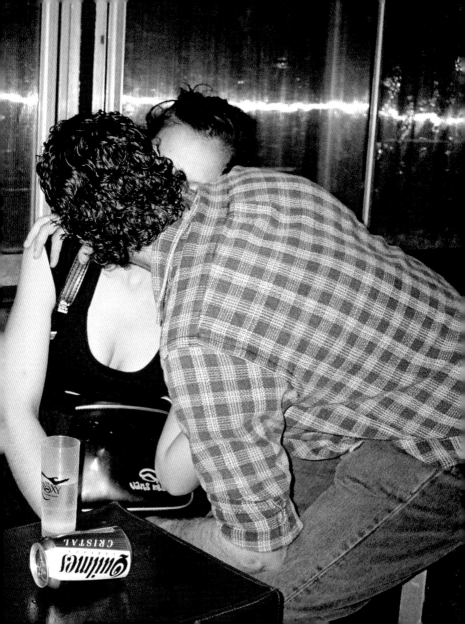

Hollywood, 2009
London, 2007

New York City, 2007
Panama, 2008

Glasgow, 2009

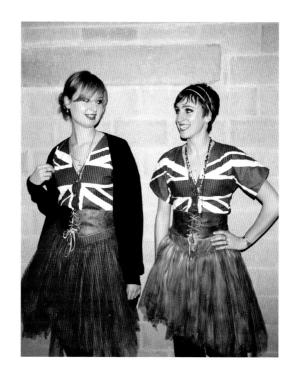

Belgium, 2009

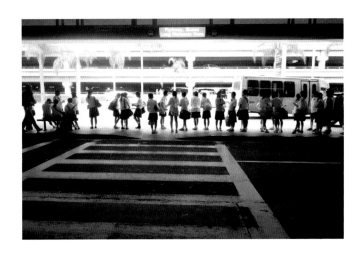

Los Angeles, 2006

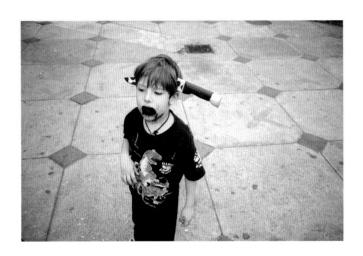

Guadalajara, 2006

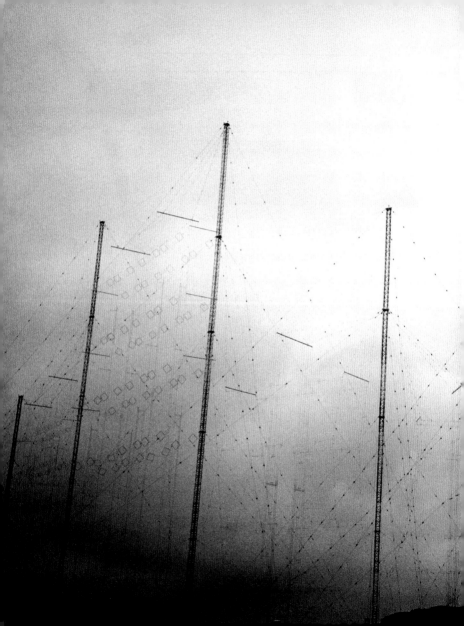

V.

YOU CAN
ALWAYS
DO BETTER

I don't know why women, as a gender, have such shitty taste in men. I'm just glad that they do. A great amount of intellectual effort has been devoted to the Billy Joel/Christie Brinkley question. But that has largely been focused on the aesthetic issues and I don't think those are the overriding factors. I don't

think she was with him for his fabulous wealth or because he wrote that pretty killer song about riding your motorcycle in the rain. I have to believe that his being, by all appearances, a complete cocksucker, a problem drinker prone to tantrums, and a mediocre talent with an inflated sense of his own capacity for empathy, played parts in her loving him unreservedly. Now he's with that shrill waitress who, at the risk of undercutting my argument, probably is in it for the cash. Regardless, when I am going through a dry spell and all my late-night texting is going unanswered and the morning light coming through my windows is telling me that everyone has wised up, it is Billy Joel I look to—and hope blooms again.

I understand if, to those who find my jokes obtuse and my manner grating, it seems self-deceptive to talk

so grandly about women falling at my moist white flounder feet. What can I tell you? Women make poor choices all the time. When I meet these women, the first thing I tell them is, "You can do better." I don't necessarily believe this. But even if they can't do better, I always think that, accepting even the possibility of a larger justice in the universe, they should be able to do better. If that's not the same thing, I can't be blamed for looking to the stars.

The women I know like to date guys in bands. They are often surprised to find out how boring these men are. Men in bands like to talk about old records and they like to put their dicks in things. Some of them also cook. These are the "smart" ones. If you think the band guy that you're following around like Jennifer Aniston is a decent, thoughtful man and well read,

here's what you do. Compare him to the absolute worst person you know who isn't in a band. The worst. Do you know Stalin? Okay. Compare him to Stalin. Who reads more (and not books about other musicians, they don't count)? Who is quicker to text you back for something other than coke sex? Who remembers the names of even one of your friends that they haven't previously slept with? And finally, after a night out with Stalin and a night out with guy in band, compare how many cigarettes you have left. See? This shit isn't complicated.

It may seem intellectually dishonest to talk only about women's poor taste and ignore men's bad decisions, but, in my experience, men make better choices. I've met some of these guys' girlfriends and I have to say, I like them. I like their hair and I like

their expansive notions of what constitutes jewelry and acceptable behavior. And I like all the women who have deigned to spend any amount of time with me too. Okay, maybe not all of them, but a sizable majority. Some were rude to my female friends and some asked for directions to the bathroom and then wet my bed. But for most I have nothing but gratitude and sympathy and an undying reserve of lust for. If you met them, and I suspect you have, I'm sure you feel the same.

My taste in women is maybe not yours. I prefer Zohra Drif to Feist, or Cat Power, or whoever it currently is that men who aren't quite brave enough for an Asian fetish fantasize about. When I walk by the new coffee shop on Lorimer, the adorably L-train-centrically named Second Stop Café, designed to resemble the

cafés that the Pied-Noirs frequented in *The Battle of Algiers*, I think, "I could really love a woman who could kill all these people."

Grace Hartigan said, "I'd much rather be a pioneer of a movement that I hate than the second generation of a movement that I love." When I was callow and handsome, I felt the same way about girls. Now I prefer a little wear around the edges, laugh lines that don't come from laughter. The women I love usually smell of vodka, sometimes with a hint of pineapple, and sometimes with a tang of cranberry. I don't like it when there's the dilution of perfume. I prefer just a nice cocktail on the throat, and maybe a little spilled on the front of the dress. Women who don't spill their drinks tend to be yellers, and not in the good way. People will try to tell you that vodka has no scent but

they're wrong. Vodka smells like a maze you have no intention of leaving.

My relationships generally start with me saying, "I have Jameson at my house." Then they stay for a week. At the end of the week, they say, "Now that we're seeing each other, you need to stop banging those other sluts." I close my eyes, count to twenty. By the time the camera pans from the blowing curtains, it's a year and a half later and all the liquor and patience have gone the way of the buffalo.

I once dated, for six months, a crazy hot racist who cried every time "You Can't Put Your Arms Around a Memory" came on the juke box. She wore leopard-print everything and a golden necklace that read *SLUT* (which, I'm not going to lie, even on our first date, I

found appealing). She gave bikers lap dances and then spit on them when they made advances. She sent me out to the bodega every afternoon for a straw for her wake-up PBR-in-bed. I feel sorry for the girls who had to follow her, so spoiled was I in her understanding of what I needed and deserved. I mean, if someone is patriotic enough to do the USO tour, they shouldn't have to go on directly after The Andrews Sisters.

I once briefly hung out with a squatter who conscientiously cared for rich folks' dogs and who has since disappeared into whatever mists squatters disappear into when they're no longer on Avenue C. She whiled away her hours getting overserved and undercharged by me at Mars Bar. I recall passing her a bag of coke and she held my hand and smiled the sort of smile that girls from homes with locks, gardens,

San Francisco, 2009

Panama City, 2008

and dads without track marks flash in their senior photos above the quotes from *Louder Than Bombs*. Then she realized what I was doing. She said, "Oh, I thought you were just being sweet," and went into the bathroom. My distaste for those who keep dogs in the city is mitigated by the memory of her slipping out of a torn, faded, and sleeveless black T-shirt in a Midtown apartment with a well-stocked medicine chest.

There has been, of course, a fair share of pathos on my end, but I fear most of it veered toward the tragicomic. There was R., who dumped me because I "couldn't fight" (I truly can't); and C., the dancer from Scores, about whom my band wrote "What They Teach You at RISD" and who invited another man along on our second date; T., who had to tolerate the sort of boy who would post Frank O'Hara's "Animals" on her

apartment door and who is now dating that marine who wrote *Jarhead*; and S., who memorably rejected me on my birthday for a member of, wait for it, The Black Halos—Canada's intensely unasked for answer to DGeneration. That was the last time I cried in public, and I should write a letter of thanks, every year, to the staff of Lakeside Lounge for setting me straight on what kind of behavior is appropriate for a man over the age of fifteen, sitting at their bar.

I have to believe in love, or something akin to it, for the same reasons that Schliemann had to believe in Troy. The stories are there. The architecture is conceivable. And the doubters are less interesting than the partisans. While I suppose myths can still sustain you even if you just see them as useful archetypes, no one wants to be a bore. Better to suspend your disbelief and worship at

an altar, any altar. After all, happiness, like patience toward small children, can be accomplished. If, that is, happiness is what you're going for.

The best relationship I ever had was with my perfect neighbor. My perfect neighbor lived a block away from me and never went to bed before noon and was generally completely faced. She had zero interest in sleeping with me but she liked having me around to talk at. I could call her at seven in the morning, on some awful pill-and-powder combination that no news weekly had gotten around to naming since no white children had died from it yet, and she would pick up after the fifth ring and say, "Of course you can come over! I have people here, it's a thing." And I would, and her friends would ignore me, or gently patronize me because I didn't know who As Four were, and I would

crawl under the covers and wait for someone to pass me a bottle or a line and then I would sleep, dreaming of exactly where I was, until the late afternoon.

My perfect neighbor was lazy about the bindings on her clothes and rigorous in her bathing, so there was always a lot of skin being shown, but it was less a tease then a sign that you were welcome to take your shoes off. And if occasionally we slipped up and maybe hands flew off in directions that maybe they shouldn't have, she always had the savvy to laugh it off and place them back in their rightful place. She came from dead parents and knew to keep love in a box with a frilly ribbon that was only to be opened on special occasions like birthdays and "Bad California Fashion" going-away parties. When she moved west, to teach something I could never comprehend at a school that's

easy to mock, I began a sulk that resembled a period of mourning. I have a framed photo of us in white 1950s yachting apparel, the night we went to *Dirty Dancing: Havana Nights*. I keep it near the foot of my bed.

A friend recently told me that he was seeing, in a professional capacity, a therapist because he was tired of waking up angry. Acknowledging the surfeit of other problems that would hopefully be addressed, I accepted this, but still thought, at the time, that if it weren't for waking up angry, I wouldn't wake up at all. Irrational, self-pitying anger that starts in the shoulders and hops merrily into the dreams is what gets me to work on time. But I never woke up angry in my perfect neighbor's bed. Confused or aroused, but never angry. And if waking up next to a beautiful Saran-wrapped weirdo, late in the afternoon, midweek with the day

ahead threatening to obliterate the happiness you'd spent the last eighteen hours scrabbling together into a shiny soap bubble of potential warmth and safety, and not wanting to punch your own mother in the face for birthing you into this awful unstable place, isn't the ideal of true romantic love, then, clearly, I have no idea what is.

Addis Ababa, 2010

Panama City, 2008

Milwaukee, 2006

Panama City, 2008

Buenos Aires, 2006
Los Angeles, 2009

Milwaukee, 2006

Tokyo, 2008

You want to know my fantasy life? It's a blanket. With a blanket on top of that one. And another, and so on, until there are blankets scraping the ceiling, and I'm Wallace Shawn, crushed under the weight of my electric blankets, cross-eyed with comfort. That's my dream. You want to give me a little kiss, that's okay with me, but tuck me in and leave afterward. Or stay and climb in, but if you do, turn on the fan. It can get awfully warm with two people under that many blankets.